MW00585848

AUNG SAN
OF BURMA

Also by Aung San Suu Kyi:

Let's Visit Burma

*Burma and India: Some Aspects of
Intellectual Life Under Colonialism*

AUNG SAN
OF BURMA

A Biographical Portrait
by his Daughter

AUNG SAN SUU KYI

KISCADALE
Edinburgh

First published in 1984 by:
The University of Queensland Press

2nd edition published in 1991 by:
Kiscadale Publications
23 Lauriston Gardens
Edinburgh EH3 9HH

ISBN1 870838 80 7

Contents

Introduction

THERE WAS a gap in Burma of forty-one years, one month
and thirteen days between the last major public speech
made by General Aung San and the first one to be given
by his daughter, Aung San Suu Kyi. In those four
decades, between July 13, 1947 and August 26, 1988, a
great deal and not much had changed in Burma. The
message given by Aung San was, as the nation he led
prepared for the challenge of independence from Britain,
much the same as the one delivered by his daughter in
1988 when, as it then seemed to her and to millions of
Burmese, the second struggle for national independence
had been joined. In very similar words, father and
daughter both emphasised the need for discipline, unity,
patience and self-sacrifice.

When Aung San Suu Kyi delivered her speech, the
image of her father was literally at hand. A vast crowd of
close to one million people had assembled on the open
ground to the west of the Shwedagon Pagoda in Rangoon
to hear her. Many carried portraits of Aung San, who is
as much a hero, if not more, to the Burmese as is George
Washington to the Americans or Winston Churchill to
the British.

The size of the audience was astonishing for a
woman of whom most people knew nothing, other than
her name. But, of course, it was also the most evocative
name in modern Burmese history. When the first pro-
democracy, anti-regime demonstrations spontaneously

Aung San

aufkommen
sprang up from within the student community in the spring of 1988 it was behind the banner of Aung San that they marched. *vorwärts schreiten* When, in August and September, the numbers of demonstrators had swelled to millions and encompassed the entire country, it was still the portraits of Aung San which were held aloft and which fell with the demonstrators as the troops opened fire.

During the early part of this period Aung San Suu Kyi was caring for her mother in a Rangoon hospital. Since the age of 15 she had spent a large part of her life abroad, although regularly visited Rangoon. As the political drama unfolded during the summer and autumn of 1988, apparently offering real hope that at last the country was emerging *sich erheben/auftauchen* from twenty-six years of international isolation and debilitating military dictatorship, Aung San Suu Kyi inevitably became swept up in the political tide. *Strömung* In her speech on August 25, she told the crowds what had happened.

"I would like to explain the part I have played in this movement. This is needed because a fair number of *Umstände/Reichweite* people are not very well acquainted *kennen* with my personal history. A number of people are saying that since I have spent most of my life abroad and am married to a foreigner I could not be familiar with the ramifications of this country's politics. *offen/freimütig*

"I wish to speak very frankly and openly. It is true that I have lived abroad. It is also true that I am married to a foreigner. These facts have never, and will never, lessen my love and devotion for my country by any measure or degree.

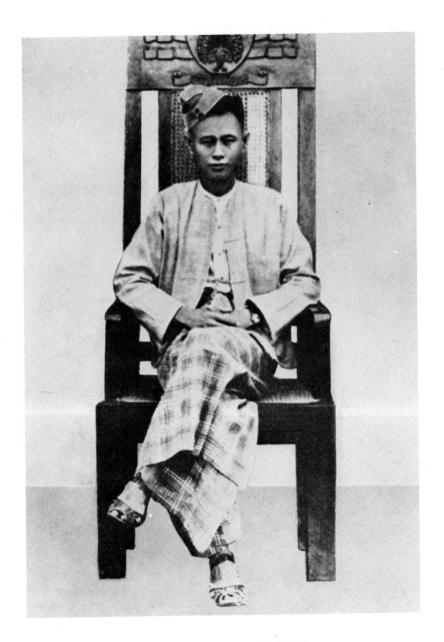

AUNG SAN, PRESIDENT OF
THE ALL BURMA STUDENTS UNION

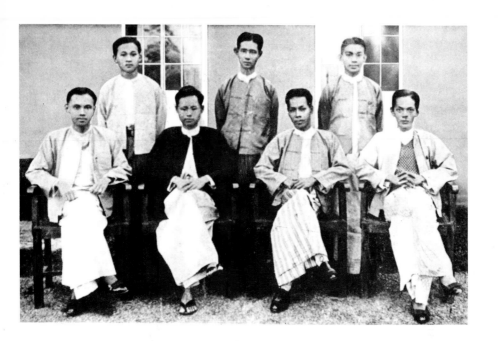

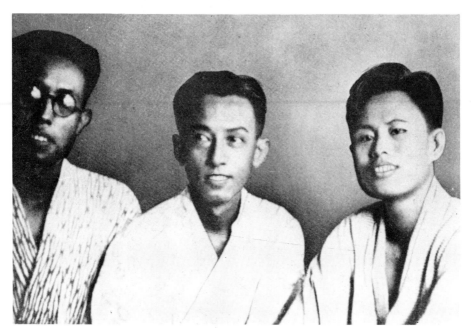

Above: EDITORIAL COMMITTEE OF OWAY MAGAZINE
AUNG SAN, THE EDITOR, IS SEATED SECOND FROM LEFT
Below: IN JAPAN 1941, BO LETYA, BO SETKYA AND AUNG SAN

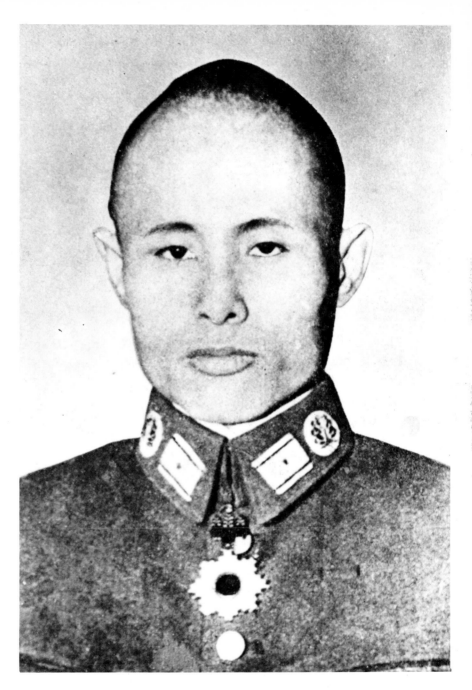

MAJOR GENERAL AUNG SAN
MINISTER FOR WAR, 1943

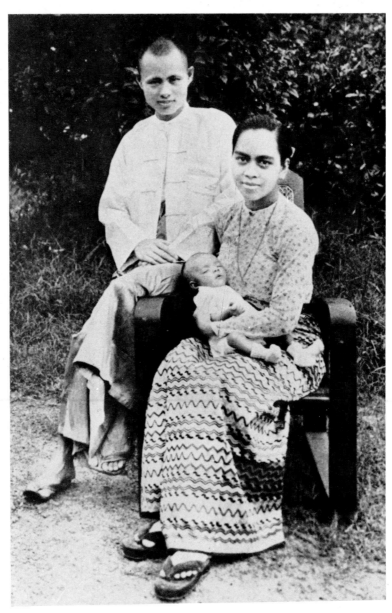

AUNG SAN, KHIN KYI AND
THEIR FIRST SON AUNG SAN OO

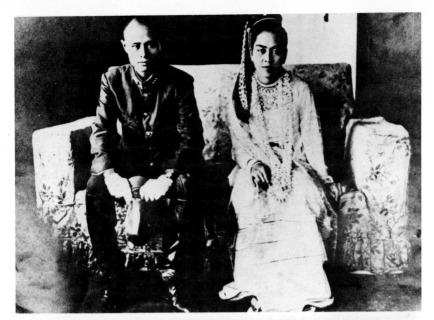

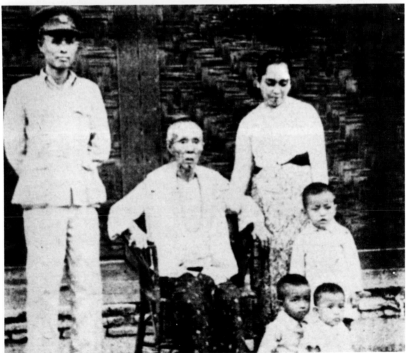

Above: WEDDING PHOTOGRAPH
OF AUNG SAN AND KHIN KYI, 1942
Below: AUNG SAN, HIS MOTHER, KHIN KYI AND THEIR
CHILDREN, THE AUTHOR IS ON THE RIGHT, LOWERMOST

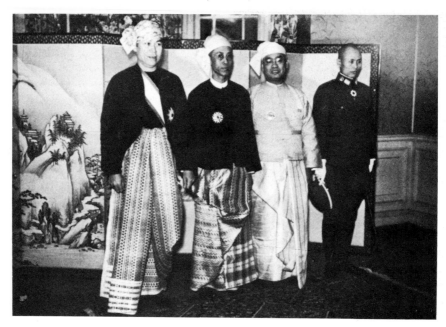

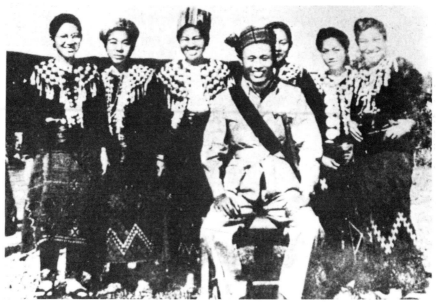

Above: THE FIRST DELEGATION TO JAPAN,
BEFORE THEIR AUDIENCE WITH THE EMPEROR,
MARCH 1943; AUNG SAN FAR RIGHT
Below: AUNG SAN WITH A GROUP OF KACHIN WOMEN

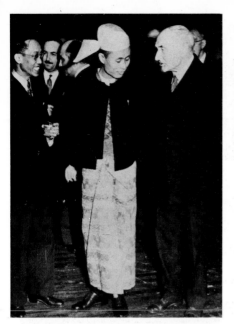
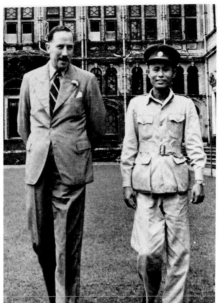
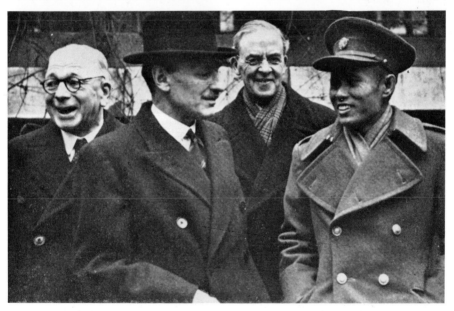

Above left: AUNG SAN IN LONDON, JANUARY 1947,
BETWEEN THAKIN MYA AND LORD PETHWICK-LAWRENCE
Above right: AUNG SAN WITH SIR HUBERT RANCE
Below: AUNG SAN WITH CLEMENT ATTLEE,
10 DOWNING STREET, JANUARY 1947

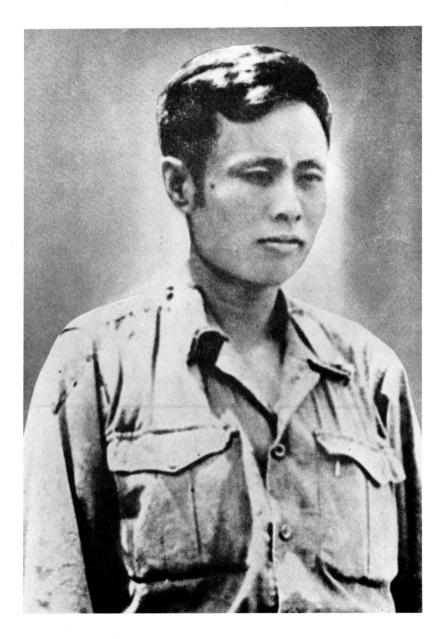

AUNG SAN AS A MEMBER
OF THE BURMA NATIONAL ARMY

Aung San Suu Kyi

"People have been saying that I know nothing of Burmese politics. The trouble is that I know too much. My family knows better than any how complex and devious Burmese politics can be and how much my father had to suffer on this account. He expended much physical and mental effort in the cause of Burma's politics without personal gain. That is why my father said that once Burma's independence was gained he would not want to take part in the kind of power politics that would follow.

"Since my father had no such desire, I, too, have always wanted to place myself at a distance from this kind of politics. Some might ask why, if I wished to stay out of politics, should I now be involved in this move- ment. The answer is that the present crisis is the concern of the entire nation. I could not, as my father's daughter, remain indifferent to all that was going on. This national crisis, could, in fact, be called the second struggle for national independence."

Aung San Suu Kyi's lack of indifference quickly propelled her into the vanguard of opposition politics. As the secretary general of the newly-formed National League for Democracy, Aung San Suu Kyi relentlessly sought to involve the equally newly-created State Law and Order Restoration Council (SLORC) in some form of dialogue about the future of the country. SLORC adamantly refused. Its first action had been to order troops to open fire on demonstrators in Rangoon, Man- dalay and other cities. Everything it did subsequently was designed to perpetuate military control and deny the

introduction of political pluralism.

Aung San Suu Kyi was rebuffed but not deterred. Despite persistent official harassment and at some risk to her own life, she toured the country bringing an alternative political message to regions and people who had heard only one version since General Ne Win seized power in 1962. In particular she pressed for the introduction of democracy and the multi-party elections promised by SLORC when it crushed the mass demonstrations in September 1988.

Her popularity grew enormously. And it was not just among the Burmese. Foreign diplomats and journalists who met her during this period, often for the first time, came away impressed by her calm, intelligence and commitment. Perhaps unfairly for someone who had been propelled so rapidly into public life, Aung San Suu Kyi was already being talked about as the best hope for a democratic Burma and as a future Prime Minister. It proved too much for SLORC. On July 20, 1989, Aung San Suu Kyi was detained and confined to her house in University Avenue where she has remained ever since. She is denied any visitors, including her husband and two sons.

Yet in May 1990 her National League for Democracy won by far the biggest electoral victory in Burma's post-independence history. It scooped up more than 80 per cent of seats in the National Assembly with NLD activists campaigning under the twin portraits of father and daughter. But not only has the party been denied the fruits of its victory, more of its leaders have been arrested.

By November 1990, SLORC had abandoned any last pretence that it was considering drawing up the new constitution on which it is insisting. Meanwhile the appalling list of human rights offences committed by servants of the regime grows even longer.

It is difficult to believe that SLORC can last for too much longer. The entire nation stands against it, the official economy survives only by selling off the country's natural resources, and most of the international community has turned its back on the Rangoon regime. In such circumstances it is helpful to remember that at the time Aung San was killed, Burma was one of Asia's most promising economies despite the terrible damage it suffered during the Second World War. Situated as it is today, close to some of the most dynamic economies in Asia while also maintaining a special place in Japanese affections, Burma could be well placed to become one of the more exciting growth prospects during the early part of the next century.

The re-issuing of Aung San Suu Kyi's study of her father's life is therefore doubly helpful. It sets Burma in the context of its struggle for independence and in so doing explores the qualities which Aung San developed during that period. Many are qualities which Aung San Suu Kyi would seek to emulate. This book, while looking back, also offers clues to the future.

Roger Matthews
London, November 1990

Preface

MY FATHER died when I was too young to remember him. It was in an attempt to discover the kind of man he had been that I began to read and collect material on his life. The following account is based on published materials; only in two instances about his personal life have I relied to some extent on what I learnt about him from my family and from people who knew him well. Writing about a person to whom one is closely related is a difficult task, and the author is open to possible accusations of insufficient objectivity. Biographers are inescapably at the mercy of the material at their disposal and to events and insights which shape their judgement. For myself, I can only say that I have tried to give an honest picture of my father as I see him.

<div align="right">

Aung San Suu Kyi
Oxford, October 1982

</div>

Chapter One
Early Influences

AUNG SAN was born at Natmauk, a small township in the dry zone of central Burma, on 13 February 1915, thirty years after the Third Anglo-Burmese War had ended the monarchy at Mandalay and brought the whole country under British rule. The people of Natmauk had a tradition of service to the Burmese kings, and some of Aung San's maternal forebears had achieved high positions in government. His father, U Pha, was of solid farming stock, unworldly, of a somewhat taciturn nature and so sparing of words that he had no success in his profession as a pleader (advocate) in spite of a brilliant scholastic record. Much of the burden of providing for the family therefore fell on the mother, Daw Su, an intelligent woman of considerable energy and spirit whose uncle U Min Yaung had led one of the earliest resistance groups against the British until he was captured and beheaded. The memory of this fiery patriot who had refused to be a subject to the *kalahs* ("foreigners from the West") was a source of great pride and inspiration to his family and to the people of his region.

Aung San, the youngest of six children, has left an unflattering description of himself as a sickly, unwashed, gluttonous, thoroughly unprepossessing child who was

so late beginning to speak that his family feared he might be dumb. However, according to those who knew him then, he also had certain lovable traits such as guilelessness, scrupulous honesty, and compassion for the poor. Aung San's family had a reputation for intelligence and learning, but while his three brothers started their education early, he refused to go to school "unless mother went too". The strong-minded Daw Su was indulgent with her youngest and allowed him to remain at home until he was nearly eight, when he himself decided that he was ready for shcool. The decision was prompted by the occasion of an elder brother entering the local monastery for the short period of novitiate customary for all Burmese Buddhist boys. Whether it was the attractions of monastic life or of the white "dancing pony" on which candidates for the novitiate were paraded around the town as part of the ordination ceremonies, Aung San expressed a strong desire to become a novice. His astute mother was quick to seize the opportunity to point out that first he would have to learn to read and write.

Aung San immediately proved to be an outstanding student, hard-working, disciplined, and always at the top of his class. He began his schooling at a monastery which also provided the elements of modern education and was thus known as a *lawkatat* ("worldly") school to distinguish it from those institutions which devoted themselves exclusively to the traditional Buddhist teachings. However, English was not taught in the schools of Natmauk, and Aung San was determined to emulate his brothers who had learnt this language, in

those days a prerequisite for higher education. Thus he moved at the age of thirteen to the National School at Yenangyaung after a brief hunger strike to gain the consent of his mother, who was reluctant to send her youngest child away from home. At Yenangyaung, Aung San had the good fortune to be in the care of his eldest brother, Ba Win, a teacher in the school, who supervised his education and well-being with a healthy mixture of strictness and common sense. The young boy continued to exhibit his academic prowess and at fifteen he won a scholarship and a prize for standing first in the pre-high school government examinations held throughout the country in the Buddhist and National Schools.

The National Schools had been founded as a result of the 1920 strike against the Rangoon University Act, which was seen as a move to restrict higher education to a small privileged class. These schools were the crucibles in which a political awareness of their colonial status and a desire to free themselves from it were fired in the hearts of young Burmese. However, the desire to free his country from foreign rule seems to have lodged itself in Aung San's mind well before he arrived at Yenangyaung. He has written that as a small boy he often dreamt of various methods of rebelling against the British and driving them out, and sometimes indulged in fancies of discovering magical means to achieve the same purpose. At the National School he began to take an interest in the speeches of political personalities and to participate in debates. Although the style of his delivery was uninspiring, his conviction and the thoroughness with which

he prepared any subject he tackled earned him a reputation for eloquence. He also edited the school journal, but in spite of such extra-curricular activities, he remained awkward and often lost in thought and was considered a strange fellow by his schoolmates. In 1932 he matriculated in the 'A' category with distinctions in Burmese and Pali and went to study at Rangoon University.

The year that Aung San joined the university was the year after the Saya San uprising had been suppressed and its leaders executed. This rebellion, which had its roots in the sufferings of the agrarian population, was played down by the British as a mere peasants' revolt led by a superstitious fanatic who wanted to be king. But among the Burmese it aroused greater sympathy than might have appeared from the degree of active involvement. Even those who did not find Saya San himself an attractive figure were stirred by the courage and nationalist spirit of the rebels and moved to pity by the harsh reprisals taken by the government.

The Burmese had never become reconciled to foreign domination in spite of the fair measure of success obtained by the pacification policy the British had pursued in the early years of their administration. As the colonial government became firmly established, the superior attitudes adopted by the foreign rulers together with their inadequate concern for the true welfare of the country began to foment the resentment of the people. The early nationalist organizations were devoted to the preservation and purification of the Buddhist religion and traditional Burmese culture, but as the number of

modern-educated youth increased, political aspirations
began to make themselves manifest. The Young Men's
Buddhist Association (YMBA), founded in 1906, was
the first body to espouse political causes and was the
organizer of the successful strike against the Rangoon
University Act. As the nationalist movement gathered
momentum, the YMBA was metamorphosed in 1920
into the General Council of Burmese Associations
(GCBA), which might be called the first national alli-
ance. Burmese nationalism was given a combative im-
pulse by U Ottama, a learned Buddhist monk who
roused the patriotic fervour of the nation with his
spirited agitations for the freedom of Burma. However,
the impetus for a concerted independence movement
was diverted by the secession of the "Twenty-one Party"
from the GCBA in 1922, followed by further splits
within the associations which finally resulted in three
different factions by the end of the 1920s. The begin-
ning of the 1930s saw Burmese politicians, some of
whom had come into prominence by defending the Saya
San rebels at the government trials, wrangling over the
question of whether or not Burma should be separated
from India under the British administration. In the
meantime, the days of quiescence were running out and
a younger generation of nationalists was coming on the
scene who would have fewer inhibitions about using
militant tactics.

Aung San at eighteen was a raw country lad, dour of
expression and untidy of dress, quite out of place among
the dapper students of Rangoon University who rather

fancied themselves the cream of Burmese youth. Moreover, he quickly established his indifference to the disapproval and ridicule of his more sophisticated contemporaries. At the end of a debate in English organized by the Students' Union during his first term, Aung San rose from the floor to support the motion which had been proposed by his elder brother, that monks should not participate in politics. This was a case of conviction rather than of family solidarity. Aung San's badly accented, clumsy English and unpolished manner of delivery made his speech practically incomprehensible, raising jeers and catcalls and causing his brother some embarassment. However, Aung San was not to be intimidated or shouted down, He continued until he had said all he wanted to say, interweaving his inadequate English with Pali words and phrases, ignoring the insults and the rude interjections to stick to Burmese.

This debate set the precedent for many subsequent occasions when he would insist on having his say in English amid the groans and abuse of the audience, and this, together with his moodiness, earned him a reputation for being thoroughly eccentric, even mad. But Aung San was not one to let himself be deterred from any task he set himself by fear of criticism. He recognized the importance of English in the contemporary world and worked hard to improve his command of the language, reading voraciously, listening to others, and enlisting the help of a close friend who had had the advantage of studying in an English medium school. In this way he achieved a proficiency in the language unusual for one

of his up-country origins and monastery school beginnings.

It is worth noting here that the motion Aung San supported in that first debate expressed one of his lasting convictions: that monks should not participate in politics. He was to say in a speech made little more than a year before his death that to mix religion with politics was to go against the spirit of religion itself. He appealed to the *sangha* (the community of Buddhist monks) to purify Buddhism and "broadcast it to all the world so that all mankind might be able to listen to its timeless message of Love and Brotherhood till eternity…this is the highest politics which you can do for your country and people."[1]

Aung San, whom popular opinion has often cast in the role of a completely political animal, had a deep and abiding interest in religion. As a student at Yenangyaung, the sorrow of his father's death had filled him with a desire to become a monk. Later, towards the beginning of his university career, he apparently conceived a great admiration for an Italian Buddhist monk, U Lawkanada, and asked his mother's permission to follow the venerable *sayadaw* ("holy teacher") in his missionary work. Permission was refused, but his preoccupation with spiritual matters did not cease. Even after he had entered the world of student politics, which was to absorb him so completely, he wrote to one of his closest friends of his "pilgrimage in quest of Truth and Perfection" and of his conscious striving after "sincerity in thought, word, and deed". He also expressed his concern over the "spiritual

vacuum…among our youth" and the fear that "unless we brace ourselves up to withstand the tide…we will soon be spiritual bankrupts par excellence". [2]

Chapter Two
Student Politics
and the Thakins

AUNG SAN'S involvement in student politics was gradual
at first, then rapidly accelerated after 1935. By this time
he had started to work with such people as Nu, Hla Pe
(later known as Let Ya), Rashid, Thein Pe, and Kyaw
Nyein. It was with these young men who were to become
well-known figures in the Burmese independence move-
ment that Aung San welded the student body into a
political force of some reckoning. They began by at-
tempting to penetrate the ranks of the hitherto con-
formist Students' Union, and although initially they had
little success (only Kyaw Nyein and Thein Pe were
elected in the first attempt), their spirited nationalism
and hard work soon paid dividends. The mood of the
university was also shifting. Active patriotism was in the
air. By the academic year 1935/6, the group of young
nationalists had captured all the major posts of the
Students' Union, and Aung San, who was one of those
elected to the executive committee, also became the
editor of the union magazine.

It was the publication in the union magazine of the
article "Hell Hound at Large" which indirectly helped to

trigger off the far-reaching university strike of 1936. The article was taken to be a scurrilous attack on a university official, and the authorities demanded the name of the author from Aung San, who refused on the grounds that it would be against journalistic ethics. This provided the administration with an excuse to serve the editor with an expulsion notice. As Nu had also been expelled very recently for his abrasive criticism of the principal, indignation ran high among the students. They decided to call a strike. It was the time of the university examinations, which made the decision a serious one and gave it much publicity. The sympathies of the newspapers and the country were immediately with the strikers, and this, together with their impressive organization and discipline, brought them vividly to the attention of the older politicians, who suddenly became aware of the potency of student power. The government was forced to consider the grievances of the strikers seriously, and the eventual outcome was the retirement of the high-handed principal, the forming of a committee to look into the amendments the students wanted incorporated into the University Act, and virtual concession to the less important demands.

The 1936 strike, which was an important landmark in the political development of the young nationalists, made Aung San widely known as a student leader. His prestige grew steadily, and he progressed up the executive posts of the Rangoon University Students' Union as well as the All Burma Students' Union, which had been founded after the strike. By 1938 he had become the

president of both bodies. In the meantime, having received his B.A. degree, he had started to read for a degree in law, partly to enable him to stay on at the university. His honesty, single-mindedness, and capacity for work won him considerable respect, albeit reluctant, but he was a difficult personality and stood apart from his more courteous and easygoing colleagues. There was much criticism of his moods, his untidiness, his devastating fits of silence, his equally devastating fits of loquacity, and his altogether angular behaviour. He himself admitted that he sometimes found polite, refined people irksome and would long to separate himself from them to live the life of a savage. But his view of savages was the romantic one of pure, honest, healthy beings revelling in their freedom.

In 1938 Aung San left the university to become a member of the *Dohbama Asi-ayone* ("We-Burmese" Organization), a party that had its origins in the Indo-Burmese riots of 1930. Its character was nationalistic, young, and vigorous, and its leaders were a breed apart from the older politicians who were either not bold enough, not Burmese enough, not radical enough, or perhaps simply not young enough for the new generation of educated youth who were passionate to dedicate themselves to the patriotic cause. The *Asi-ayone* members were not universally popular, there were those who looked down on them as brash young upstarts or feckless trouble-makers and found their use of the prefix *Thakin* affected and objectionable. *Thakin*, which means "master", was the term by which the British rulers expected

to be, and for the most part were, addressed by their Burmese subjects. By appropriating the title for themselves, the young "Thakins" proclaimed the birthright of the Burmese to be their own masters and gave their names a touch of pugnacious nationalism. Internal friction split the organization into two, and Aung San joined the majority faction led by Thakin Kodaw Hmaing, the "Grand Old Man of Letters and Politics", who had originally been a patron of the Asi-ayone. It was this faction which was also chosen by Nu, Hla Pe, Thein Pe, and two others who had not been among the student leaders but who were to play prominent roles in Burmese politics, Than Tun and Soe. Aung San soon became the general secretary of the Dohbama Asi-ayone and later drafted its manifesto.

During 1938/9, momentous events occurred which were collectively known as the Revolution of 1300 (the year according to the Burmese calendar, which begins its new year in mid-April). There was the march of the Yenangyaung petroleum workers, the march of the peasants on Rangoon to demand agrarian reforms, the student protests in which Aung Gyaw was mortally wounded in a police baton charge, the consequent school strikes all over the coutnry, the communal riots between the Burmese and the Indian Muslims, the labour strikes, the Mandalay demonstrations in which seventeen people died under police fire, and the fall of the government of Prime Minister Ba Maw. All these combined to create a ferment of unrest such as the nation had not known and speeded up the tempo of nationalist activities. But even

amid such stirring events, those two scourges of Burmese politics, factionalism and jealousy, began to cast their shadow. The desire to claim the distinction for being the more effective, the most patriotic, the best was to seize groups and individuals and lead to recriminations and bitterness.

Aung San was one of the few considered above faction and jealousy. He had leftist leanings and was a founder member and general secretary of a group started in 1939 which some describe as a Marxist study group and some call the first Burmese communist cell. But Aung San was not fanatical in his belief in communism or any other rigid ideology. He found much to attract him in the broad range of socialist theories, but his real quest was always for ideas and tactics that would bring freedom and unity to his country. In 1939, soon after the outbreak of the war in Europe, seeing the "Colonialism's difficulty is Freedom's opportunity", he helped to found the "Freedom Bloc", an alliance of Ba Maw's *Sinyetha* party, the Dohbama Asi-ayone, the students, and some individual politicians. Ba Maw was made the *Anashin* (literally "Lord of Power") and Aung San the general secretary of the bloc, which Nu has dubbed the "brainchild of Thakin Aung San". The message of the Freedom Bloc to the nation was that the people would support the British war effort only if they were promised independence at the end of the war; if the British government was not prepared to make such a declaration, the people should oppose the war effort strenuously. The authorities responded by making large-scale arrests of national-

ists; by the end of 1940, many of the Thakin leaders and Ba Maw were in gaol. A warrant for Aung San's arrest was also issued, but he received a timely warning and disappeared.

Chapter Three
Alliance with the Japanese

AUNG SAN had been contemplating the necessity for an armed struggle for some time. Yet in spite of the dreams of his childhood, he had not always ruled out the possibility of achieving independence through constitutional means. As a university student he had considered taking the Civil Service examinations and perhaps following the example of Indian politicians, whom he admired for their educated conduct of politics as well as for their patriotism. It has also been said that after he had become a well-known student leader he wrote to the professor of English at Rangoon University that he was a "peaceful revolutionary". However the tide of events in Burma caused him to change his views. He has described his thinking in 1940 thus:

> Personally though I felt that international propaganda and assistance of our cause was necessary, the main work, I thought, must be done in Burma which must be the mobilization of the masses for the national struggle. I had a rough plan of my own - a country-wide mass resistance movement against British imperialism on a progressive scale...co-extensive with international and national developments in the form of series of local and partial strikes of industrial and rural workers leading to general and rent strike finally, also

all forms of militant propaganda such as mass demonstra-
tions, and people's marches leading finally to mass civil
disobedience, also economic campaign against British im-
perialism in the form of boycott of British goods leading to
the mass non-payment of taxes, to be supported by develop-
ing guerrilla action against military and civil and police
outposts, lines of communications, etc., leading finally to
the complete paralysis of the British administration in
Burma when we should be able along with the developing
world situation to make the final and ultimate bid for the
capture of power. And I counted then upon the coming over
of the troops belonging to the British government to our side
- particularly the non-British sections. In this plan I also
visualised the possibility of the Jap invasion of Burma - but
here I had no clear vision (all of us at that time had no clear
view in this respect though some might now try to show
themselves, after all the events, to have been wiser than
others...).[3]

Aung San admitted that this was a "very grand plan
of my own" which did not appeal to many of his com-
rades, partly because of "our petit-bourgeois origin"
which made "several of us hesitant before any decisive
action even though we might think and talk bravely",
partly because they were impatient at the idea of the
"seemingly prolonged and difficult work of arousing the
masses" and partly because "most of us even though we
might talk about mass action and mass struggle were not
so convinced of its efficacy". However, Aung San per-
sisted in the view that it would be necessary to try to get
hold of arms to enable the nationalists to carry out
guerilla action, and finally it was decided that one of
their number should go outside Burma to seek aid and

weapons. "And as I was the only one leading an under-
ground existence, " he wrote, "I was chosen for the
task."[4]

In August 1940 Aung San and another Thakin, Hla
Myaing (later known as Yan Aung), left Burma on the
ship Hai Lee and reached the international settlement
of Kulangsu at Amoy in China. For a few months they
were stranded there, vainly trying to establish contact
with the Chinese Communists. The Communist con-
tacts did not materialize, but they were approached by a
Japanese agent and flown out to Tokyo to meet Colonel
Keiji Suzuki, an officer of the Japanese army, who was to
become famous as the head of the Minami Kikan, a secret
organization whose task would be to "aid Burmese in-
dependence and to close the Burma Road".[5]

Contact between Burmese politicians and the Japa-
nese was not an entirely new development. Saw, who
had replaced Ba Maw as Prime Minister, was reputed to
have made his fortune from Japanese funds, and Ba Maw
had also sought the aid of the Japanese for the Freedom
Bloc. Yet another veteran politican and one-time min-
ister in the Ba Maw government, Thein Maung, had
visited Japan, sponsored the Japan-Burma Friendship
Association, and met Suzuki on the latter's visit to
Burma in mid-1940. It was through this contact that the
Japanese had managed to locate the two Thakins in
Amoy. The members of the Freedom Bloc were divided
whether or not they should accept Japanese help, the
Communists (of whom Soe, Ba Hein, Than Tun, and
Thein Pe were pre-eminent) especially opposing the

idea of co-operation with fascist Japan. Aung San how-
ever took the pragmatic view that they should accept
help from any quarter that offered it and see how the
situation developed. However, as his own words indi-
cated, he did not seem to have thought out the conse-
quences clearly.

In Tokyo, Aung San and Suzuki established a kind
of mutual understanding, but there seemed to have been
reservations on both sides. While Suzuki respected Aung
San for his honesty and patriotism, he thought that "his
political thinking was not so mature",[6] a not altogether
unjustified criticism at that time, for Aung San himself
has written that he and his comrades had invited the
Japanese invasion "not by any pro-fascist leanings, but
by our naive blunders and petit-bourgeois timidity". He
had been apprehensive on his way to Japan, and al-
though he was relieved to find on arrival that it was "not
so bad", he still had misgivings. While admiring the
patriotism, cleanliness, and self-denial of the Japanese
people, he objected to the "barbarity" of some of their
militarist views and was somewhat shocked by their
attitude towards women.[7]

Aung San came back to Burma in February 1941
disguised as a Chinese seaman. He brought an offer from
the Japanese which the Burmese understood to be one of
arms and money to support an uprising. There would
also be military training for a select group of young men
who would have to be smuggled out of the country. Aung
San himself did not remain long in Burma but went back
to Japan with Hla Pe and three others, the vanguard of

the group that was to be known as the "Thirty Comrades". The selection of these thirty, who were to become the core of the Burma Independence Army, was decided partly by availability, which precluded those nationalists who were in gaol, and partly by a desire to appease contending factions within the Thakin party, which sowed the seeds for future dissension.

On Hainan island, where the thirty received strenuous military training, Aung San, Hla Pe, Tun Ok, and Aung Than (later known as Setkya) were selected to specialize in high command and administration. Tun Ok, who represented one faction of the Thakin party, was chosen as the "political leader" of the group, but it was Aung San who emerged as the unmistakable leader not just of the Thirty Comrades but of the Burma Independence Army when it was created. Although Aung San was slight and not particularly robust, he proved to be a soldier of great skill and courage, able to bear much hardship. And for all the charges of "poor at human relations" which had been levelled against him, it was he who rallied the men when their bodies and spirits flagged, showed special concern for the youngest ones, and counselled self-restraint when feelings ran high against either camp life or the Japanese. For in spite of the respect and even affection that many of the young trainees conceived for some of their instructors, the Burmese found certain Japanese attitudes highly objectionable, and friction began to develop between the two races even before the invasion of Burma at the end of 1941.

Aung San

The Burmese Independence Army (BIA), a force comprising the trainees of the Hainan camp, Thai nationals of Burmese origin, and members of the Minami Kikan, was officially launched in Bangkok in December 1941. Suzuki was the commanding officer with the rank of general; Aung San, as chief-of-staff, was made a major-general. The members of the fledgling army took an oath of loyalty, and the officers adopted valorous-sounding Burmese names, transforming Suzuki to *Moegyo* ("Thunderbolt") and Aung San to *Teza* ("Fire"). Others of the Thirty Comrades who were to become well known by their new names included such men as Let Ya, Setkya, Zeya, Ne Win, Yan Naing, and Kyaw Zaw. "Major-General Teza", however, was to revert to the name by which he had been known to the country as a student and Thakin leader, and it was as *Bogyoke* (General) Aung San that he was to be idolized as the hero of the people.

The march of the BIA into Burma alongside the Japanese troops was an occasion of great pride and joy to the Burmese, who felt that at last their national honour had been vindicated. But already Aung San and some of his comrades knew that there was trouble ahead. He has left on the record that while still in Bangkok he tried to arrange for the nationalists in Burma to organize independence so that the Japanese would be confronted with the accomplished fact. Failing that, the masses were to be mobilized and underground activities initiated to prevent the invaders from consolidating their position. However, Burma was in disarray and most of her politicians were in prison, so neither of the plans was practi-

cable and the Japanese occupied the country. The story of the Japanese occupation is one of disillusion, uncertainty, and suffering. Those who had believed they were about to gain freedom from the British were shattered to find themselves ground under the heels of their fellow Asian instead. The soldiers of Nippon, whom many had welcomed as liberators, turned out to be worse oppressors than the unpopular British. Ugly incidents multiplied daily. *Kempei* (the Japanese Military Police) became a dreaded word, and people had to learn to live in a world where disappearances, torture, and forced labour conscription were part of everyday existence. In addition, there were the ravages of both Allied and Japanese bombings, the shortages of wartime, the informers, the clashes between different temperaments and cultures, the inevitable misunderstandings between people without a common language. There were of course Japanese who lived in accordance with the principles of justice and humanity and who befriended the Burmese, but their postiive contributions were lost beneath the welter of militarist racism.

The members of the Minami Kikan who felt honour-bound to give Burma her promised independence seemed to have been unhappy with the way the situation had developed. Suzuki had in fact set up a central government of Burma with Tun Ok as the head soon after Rangoon had fallen to the Japanese in March 1942. But that government was short-lived, for as the occupation of the country proceeded, the Japanese military administration took over and Burma began to be treated more

and more like a piece of conquered territory. The position of the Burma Independence Army was uncertain and unenviable. Its ranks had been swelled rapidly by eager recruits who had joined them on their march, and these new soldiers had yet to be trained and disciplined into effective troops. Aung San had not been given command of his men; he was simply Suzuki's senior staff officer, while Suzuki himself seemed to have been having difficulties with the military administration over the role he and the BIA were to play in the future of Burma. On the part of Aung San and his comrades, there was the growing feeling that the BIA commands should be transferred to Burmese officers. Let Ya has described a dramatic scene in which he, Aung San, and several other members of the Thirty Comrades confronted Suzuki over the matter. The outcome was Aung San's appointment as commander-in-chief of the BIA with Let Ya as the chief-of-staff.

Aung San had no illusions either about his position or about the plight of the country. He concentrated on strengthening and disciplining the army, aware that the struggle for independence was far from over. He also tried to keep the BIA away from party politics and from interfering in civil administrative matters, but he must have known that it was already too late to keep politics out of an army that had been created with politicians at its core. In July 1942 Suzuki left Burma and the BIA was reorganized as the Burma Defence Army with Aung San as the commmander-in-chief bearing the rank of colonel. However, there were Japanese military "advisers"

attached to the new army at every level and the actual powers of the Burmese officers were heavily circum-scribed. In August, the commander of the Japanese forces in Burma, General Iida, inaugurated the Burmese administration and Ba Maw was appointed Chief Ad-ministrator. On the surface it seemed as if the govern-ment of Burma had passed to her people; in fact it was the entrenchment of Japanese military rule.

Chapter Four
Resistance

AUNG SAN and his comrades had suffered great physical hardship on their march with the BIA, and as malaria and exhaustion caught up with them, many of them landed in hospital. The Rangoon General Hospital, where Aung San and a number of his colleagues found themselves, was run by a group of dedicated doctors and nurses trying to provide medical care against great odds. Aung San was celebrated for his stern looks and impenetrable moods, which, together with his growing reputation as a hero, made him an object of awe to the junior nurses, who hardly dared approach him. He therefore came under the care of the senior staff nurse, Ma Khin Kyi, an attractive young woman of great charm whose dedication to her work of healing had won the respect and affection of patients and colleagues alike. She handled Aung San with firmness, tenderness, and good humour. The formidable commander-in-chief was thoroughly captivated. His shyness and sense of mission had kept him away from women, and he was straitlaced to the extent that when in Tokyo, Suzuki had offered him a woman, presumably out of a sense of Japanese courtesy, he was deeply shocked and wondered if the older man were trying to "demoralize" him. But Aung

San knew what he wanted, and he was nothing if not straightforward. After a brief courtship, he and Ma Khin Kyi (later known as Daw Khin Kyi) were married on 6 September 1942.

It has been said that "Daw Khin Kyi, in marrying Aung San, married not a man only but a destiny".[8] And Aung San had married a woman who had not only the courage and warmth he needed in his life's-companion but also the steadfastness and dignity to uphold his ideals after he was gone. Theirs was a successful union, and the soldiers who had not been entirely happy at the idea of their adored young commander getting married were soon won over. Marriage brought out the gentler traits in Aung San's character, and he proved to be a loving husband and father. To have by his side an understanding companion who was able to share his hard and dangerous life undoubtedly strengthened him for the momentous tasks that lay ahead.

In March 1943, Aung San was promoted to the rank of major-general and invited to Japan to be decorated by the Emperor. The delegation to Tokyo was led by Ba Maw and, besides Aung San, included two eminent Burmese statesmen, Thein Maung and Mya. The Japanese Prime Minister, General Tojo, had already announced in January that Burma would soon be declared an independent state, and the Burmese party came back carrying a document that said, in Aung San's laconic words, "that Burma would be granted independence on 1st August 1943 and that we were to conclude certain treaties and so forth". He did not take it terribly seri-

ously. On 1st August Burma was duly declared a sovereign independent nation and a co-equal member of the Greater East Asia Co-Prosperity Sphere. Ba Maw was appointed head of state with the title of *Adipati* ("Great Lord") as well as Prime Minister, while Aung San became the War Minister. The Japanese tried various tactics to render the Burmese forces, renamed the Burma National Army (BNA), ineffectual, first scattering them around the country, then concentrating them in a few places, trying to make contact between the War Ministry and the troops difficult. Aung San was unperturbed. He agreed to everything the Japanese suggested, kept his own counsel, and made his plans.

It must have been around the time he came back from Tokyo that Aung San summoned a few of his army officers, including Let Ya, Zeya, Ne Win, and Kyaw Zaw, to discuss the timing of the resistance. The officers recommended waiting until things were better organized, and it seemed that Aung San agreed reluctantly only after he had discussed the matter with Than Tun, who also expressed the opinion that the time was not yet ripe. Other Communists, in particular Soe and Thein Pe, had been preaching resistance against the Japanese even before the retreat of the British had released them from prison. With the advance of the Japanese army they had both gone underground, and Thein Pe, after a brief meeting with Aung San and Ne Win at Shwebo, made his way to India to try to contact the British troops. By November 1943, plans for the resistance had gone far enough for a Major Seagrim, who was hiding in the hills

of Burma trying to organize a force of irregulars, to report to India that "a certain Aung San of the Burma Defence Army was planning to turn his forces against the Japanese when the opportunity presented itself".[9] Meanwhile, Aung San had to allay Japanese suspicions until preparations for the resistance were completed, but he made bold public pronouncements which told the people that their present "independence" was a counterfeit and that the struggle for the real thing was yet to come.

Towards the end of 1942, clashes had broken out between irresponsible elements among the BIA and the Karens, one of the main ethnic groups within the country, leading to much bloodshed and racial strife. Aung San had always laid great importance on good relations between the different races of Burma, knowing that it was essential for the unity of the nation. In the "Blue Print for Burma" which he had drawn up for Suzuki in 1940, he had already stressed the need to "bridge all gulfs now existing through British machinations between the major Burmese race and the hill tribes, Arakan and Shan State, and unite those all into one nation under the same treatment".[10] The conflict between the Karens and the Burmese greatly troubled him. Throughout the latter part of 1943, he, Than Tun, and Let Ya laboured to bring about peace and understanding between the two races. Their concerted efforts were rewarded; the Karens learnt to trust the Burmese leaders to the extent that a Karen battalion was added to the Burmese army.

Another burning problem Aung San had to resolve was the enmity that was steadily growing between the

Communists and the socialists of the Burma Revolutionary Party. The Communist leaders were Soe (who continued his underground existence throughout the Japanese occupation), Than Tun (who had become the Minister for Forests and Agriculture), and Ba Hein, while Kyaw Nyein and Ba Swe were two of the most prominent and active socialists. Aung San worked hard to bring the two sides together. Such a conciliation was made more urgent by the fact that the political differences had seeped into the army and were threatening its solidarity and therefore the chances for a successful resistance. Moreover, Soe had been disseminating propaganda harmful to the BNA in the course of his anti-fascist campaign, creating much resentment within the ranks and angering Aung San himself. After months spent in exchanging views, Aung San had a secret meeting lasting several days in August 1944 with Soe, Than Tun, and Ba Hein. Aung San's proposal for an anti-fascist organization was discussed and a draft manifesto for the organization and a plan for concerted action approved. Soon after, a meeting was arranged between the Communist leaders and members of the Burma Revolutionary Party, at which Aung San read out a proclamation in Burmese entitled "Rise Up and Attack the Fascist Dacoits", officially launching the Anti-Fascist Organization (AFO). Soe was the political leader, Than Tun the general-secretary, also in charge of liaison with the Allied forces, and Aung San, the military leader. There were at the time some younger officers in the BNA who were impatient for action and frustrated

by the reticence of Aung San, who limited his circle of conferees to a few Thakin leaders and senior army officers. The younger officers were planning to pull off a resistance on their own. On discovering this, Aung San resolved the situation by giving them specific roles to play within the AFO movement.

Once the internal forces were united, it only remained to see what kind of terms could be arranged with the Allied forces before finalizing plans for the resistance. Aung San and the AFO leaders had decided to rise against the Japanese with or without external help but there were obvious practical advantages to be gained from co-operating with the increasingly victorious Allied forces. In the event, no clear understanding had been reached with the British by the time the resistance started on 27 March 1945, when Burmese troops throughout the country rose up against the Japanese. Ten days previously, Aung San had taken part in a ceremonial parade in Rangoon at the end of which he and his men marched out of the capital for "manoeuvres". Slim's Fourteenth Army had already crossed the Irrawaddy north of Mandalay, and Than Tun had left for Toungoo to try to rendezvous with a British army officer. The resistance was soon in full spate. On 15 May Aung San, accompanied by a staff officer, went to meet Slim at the latter's headquarters. In the interview that followed, Aung San took a bold line, introducing himself as the representative of the provisional government of Burma and demanding the status of an Allied commander. But while trying to get the maximum concessions out of the

British officer, he showed himself to be realistic, co-operative, and disarmingly honest, winning Slim's liking and respect. In the latter's words, "The greatest impression he made on me was one of honesty. He was not free with glib assurances and he hesitated to commit himself, but I had the idea that if he agreed to do something he would keep his word."[11]

After the meeting between Aung San and Slim, the Burmese and the Allied troops joined in the operations against the Japanese army, which rapidly crumbled. By 15 June, a victory parade was held in Rangoon at which the Burmese army participated alongside units representing British Empire and Allied forces. The resistance against the Japanese was over. It had been the finest hour for the Burmese nationalists when ideological differences and personal considerations had been put aside for a common cause. In August 1945 the AFO was expanded to include organizations and individuals representing a broad spectrum of social and political interests and renamed the Anti-Fascist People's Freedom League (AFPFL).

Chapter Five
Negotiations with the British

THE DECISION of the British to accept the offer of the AFO to fight the Japanese alongside the Allied forces had been due to the political acumen of Lord Mountbatten, Supreme Allied Commander, South-East Asia. The government-in-exile set up in India after the 1942 British retreat from Burma was dominated by civil servants who had lived through times when the young nationalists had challenged their authority and disrupted their administration. These officials of the former administration were against any form of co-operation with the AFPFL, and during the period of military administration immediately following the British reoccupation of Burma, they wanted to declare the AFPFL illegal and arrest Aung San as a traitor. Mountbatten, who was in a position to be more objective, saw that to achieve a peaceful settlement in Burma it would be essential to win the co-operation of the man the people had come to regard as their deliverer. The British civil servant who headed the military administration and who was so out of touch with the mood of the Burmese people was soon replaced by Major-General

Hubert Rance, a professional soldier.

An immediate problem that Aung San had to re-solve was the future of the Burmese army, which had been renamed the Patriotic Burmese Forces (PBF). The difficulties of feeding and equipping the troops were becoming acute. After the Allied victory, Aung San had agreed at a meeting with Mountbatten that those men of the PBF who were willing should be absorbed into the Burma Army under British command. The details of this agreement were worked out and finally settled in September 1945 at the Kandy meeting between the Allied Command and a Burmese delegation which included Aung San, Let Ya, and Than Tun. On the way to Kandy, some members of the delegation had met with Thein Pe during the stopover in Calcutta to discuss the question of Aung San's future. One view was that the coming political struggle needed him, that "he was the only man who could forge a united front of the nationalist forces and give the leadership". The other view, put forward by the Communists with the exception of Thein Pe, was that Aung San should give up politics and remain in the army because he did not possess all the qualities of a political leader, his human relations were poor, and he was not skilful in political tactics. Let Ya, who strongly believed that Aung San was the national leader Burma needed to unite the forces in the "final struggle", under-stood the suggestion of the Communists to mean that "they wanted to have the political field all to them-selves, with Bogyoke out of the way but giving them indirect support, when they should need it".[12] Aung San

listened to both views and made his own decision: he would leave the army and devote himself to the struggle for independence on the political front.

The years 1945-47 saw the emergence of Aung San as a strong leader and an able statesman who had the confidence as well as the love of the people, disproving beyond doubt the criticisms of those who had wanted him to remain in the army. In May 1945 the British government had declared its future policy towards Burma in the form of a White Paper. This provided for a period of three years direct rule by the Governor and, in due course, elections, and the restoration of a Burmese Council and Legislature, which were no more than what had been established under the 1935 Burma Act. Only after the Council and Legislature had been restored would there be a step forward: the drafting of a constitution by all parties which would eventually provide the basis on which Burma would be granted dominion status. However, the hill and frontier areas would be excluded from this arrangement unless the people of these "excluded areas" specifically expressed the desire to be amalgamated with the rest of Burma.

The terms of the White Paper were totally unacceptable to the AFPFL, as Aung San and Than Tun made clear to Sir Reginald Dorman-Smith, the returning Governor of Burma, even before the end of the military administration. The leaders of the AFPFL explained that theirs was the party that represented the country and that they should therefore be allowed to form a national provisional government to replace the

military administration. Dorman-Smith was not lacking in good intentions, but he, like many of the civil servants surrounding him, was unable to grasp the fluid and complicated political climate of post-war Burma. He had difficulty in believing that the AFPFL had the popular support of the country, and although he could not fail to see that Aung San was the most important figure in Burma at the time, he seemed reluctant to accept the fact. Moreover, he was handicapped by an understandable desire to reward those elder Burmese politicians who had remained loyal to his government throughout the war, unable or perhaps unwilling to see that they no longer had a place in the political arena of the new Burma. Churchill's imperialistic refusal to consider the "liquidation of the British Empire" did not help, while his successor, Attlee, finding it difficult to "evaluate the various trends of opinion" in Burma, was slow to formulate a clear-cut policy.

Civil government was restored to the country in October 1945 when Dorman-Smith arrived back in Rangoon, emphasizing that Burma's battle for freedom was over. This, however, was not the view of Aung San and the AFPFL, who had not dismissed the possibility of further armed conflict should the British government fail to give them the independence they wanted on their own terms. The first clash came over the composition of the Governor's Council. The AFPFL insisted that seven of the eleven seats be filled by their nominees and attached other demands which were calculated to turn the Council into the national provisional government

for which they had asked in the first place. Not unexpectedly, the British government refused, and Dorman-Smith appointed to the Council and to the Legislature people he considered moderates but who included some politicians seen by many Burmese as sycophants or self-seeking traitors to the nationalist cause. In Janaury 1946, Aung San was elected president of the AFPFL by acclaim, and he set out to mobilize the country behind the league in its contest with the British government.

In spite of the Kandy agreement, there were substantial numbers of PBF veterans who had not joined the Burma Army. Aung San gathered these ex-servicemen together with new recruits to form the People's Volunteer Organization (PVO). The men of the PVO wore uniform, drilled openly, and although it was officially a welfare organization engaged in reconstruction activities, its potential as the military arm of the AFPFL made the government highly uneasy. Aung San countered the complaints of the Governor with some finesse and produced a statement in which he laid out the aims of the PVO, including "to co-operate with and help government authorities and other organizations and the public in general in the suppression of crimes and in the maintenance of law and order in the country".[13]

Dorman-Smith did not know what to make of it. He was unequal to the task of handling Aung San and the AFPFL, unable to make up his mind about the Burmese leader, oscillating between high praise and puzzled misgivings. Aung San gave indications that he would prefer to achieve independence without resorting to an

armed struggle, which would exacerbate the already severe hardships of the people. At the same time he made it evident that he would not refrain from violence should it be necessary for the freedom of Burma. In the large public meetings he addressed, as well as on such emotionally charged occasions as the funeral of peasants killed by police fire during a procession, Aung San showed himself capable of keeping the massive crowds quiet and controlled, even while he denounced the policies of the British administration and exhorted the country to greater exertions for the cause of independence.

Yet Dorman-Smith and his advisers were reluctant to accept that they needed Aung San's co-operation for a peaceful settlement and wondered if they could not set up other parties to test the power of the AFPFL. There were certainly politicians willing to take up the challenge, men of whom it would perhaps be said, as an English writer said of the Governor's Councillors, that the difference between them and the AFPFL lay not so much in their independence policies as in the rivalry for power. Moreover, Aung San's rise to national leadership and the great love and reverence, verging on worship, that he inspired in the people had aroused intense jealousy in some quarters. Just when Dorman-Smith was casting around for possible alternatives to the AFPFL and some of his advisers were clamouring for the arrest of Aung San on the grounds of sedition, Tun Ok, who was serving on the Council, brought an accusation of murder against Aung San. During the advance of the

BIA, a village headman had been tried by court martial on charges of pro-British activities, cruelty, and corruption, and the sentence of death had been carried out by Aung San. Tun Ok said he had been a witness throughout the proceedings and offered to give evidence should a trial take place.

The government was divided whether Aung San should be immediately arrested. Some British civil servants recommended the arrest, urging that it would "clear the air", avert a possible rebellion, and cause little trouble, as the people would soon forget Aung San. The Inspector-General of Police demurred, pointed out that a general pardon for war offences was under consideration, and judged that the arrest of the leader of the AFPFL and the PVO was more likely to spark off a rebellion than to prevent one. The Commander-in-Chief Burma Command supported the police view, expressing his opinion that Aung San was "too sensible" to start a rebellion. In addition, there were reservations about acting on the word of Tun Ok, whose motives were suspect and who had published a book in which he had written proudly of violent deeds he had committed during the Japanese occupation, uncompelled by force of duty. Dorman-Smith decided to discuss Tun Ok's charges directly with Aung San, who accepted full responsibility, explaining that the sentence of death had been carried out in accordance with the findings of the court martial.

The Governor was once again in a state of indecision, torn between admiration for Aung San's honesty

and "moral courage" and the contemplation of the political advantages that might possibly be gained from putting away on a charge of murder the man who was the chief adversary of his administration. Perhaps fortunately, the government at Whitehall reserved the right to decide what course of action should be taken in the matter. In April 1946, while on a visit to Singapore, Dorman-Smith received a cable directing him to arrest Aung San. The Governor flew back to Rangoon immediately to carry out the instructions. Just before the warrant could be served, another cable arrived rescinding the order.

This episode further corroded the already uncertain authority of the administration, whose every move was known to the AFPFL through their numerous supporters in the government departments. Word soon went out that although the British were eager to put away Aung San, they did not dare to touch him. Dorman-Smith tried to salvage the situation, at last admitting to London that the White Paper was unworkable and suggesting new approaches which would be acceptable to the AFPFL. But it was too late. In June 1946, amoebic dysentery sent the worried Governor back to England; before the end of July, Attlee had decided to replace Dorman-Smith with Major-General Rance. It was a happy choice, for Rance had come to know the Burmese situation well during his term as head of the military administration and was on good terms with a number of AFPFL leaders, including Aung San.

Chapter Six
Achieving Independence

WHILE THE change of governor did not change the policies of the AFPFL, it represented a change in the approach of the British government, and thus independence politics entered a new phase. The old Governor's Council was dissolved, and in September 1946 Aung San was appointed Deputy Chairman of the new Executive Council with the portfolios for defence and external affairs. The rest of the eleven-man Council included five more members of the AFPFL. As it assumed collective responsibility (although in name an advisory body to the Governor), the Executive Council became in fact the long-agitated-for national provisional government. Aung San viewed the new developments with cautious optimism. It was not yet the end of the struggle, as he pointed out at a protest meeting against the White Paper, which had not been officially discarded. He warned the people not to imagine that his acceptance of office meant the end of all problems and outlined the tasks that still lay before them. He emphasized the importance of their support to him and the AFPFL and added a personal note about himself with that frankness and simplicity which

endeared him to his countrymen.

> At this time I am a person who is very popular with the public. But I am neither a god, wizard or magician. Only a man. Not a heavenly being, I can only have the powers of a man. I am very young. The responsibility I now bear is that of standing at the very head to carry the burdens of the whole country. I do not consider that I have all the qualifications necessary to bear that burden. Also many people know that I am short tempered. That is my nature. When I am busy and harassed, I get short tempered. I shall try to correct that as much as possible. But you must also be patient. I too will be patient and if you will build up your strength to an even greater height than that which you have displayed today and support us in what we are doing for you, we shall be able to do more to achieve the independence and the public welfare that we want ...That is why I would like to ask the people once more to stand firm and resolute.[14]

The people did stand firm and resolute behind Aung San, but he was not free from opposition. More than from the political parties that tried to challenge the position of the AFPFL, troubles came from within the organization itself. Although there were few individual defections, the Communists had been working to strengthen their own party all the while they were ostensibly united behind the AFPFL front. Personal differences and ideological clashes had led to a split between the "Red" Communist faction of Soe and the "White" Communist faction of Than Tun and Thein Pe in March 1946, and the militancy of the "Red" Communists had made them illegal under the Unlawful Associations Act in July. Than Tun remained the general-

secretary of the AFPFL and Thein Pe was made a member of the new Council, but the "Thein-Than" Communists tried to place obstacles in the way of Aung San's negotiations as Deputy Chairman of the Executive Council to end the general strike that had been launched before the arrival of Rance.

Although the attempt to prevent the settlement of the strike failed, it had been only one part of a campaign which had been going on for some time to subvert the authority of Aung San and the AFPFL. Such a situation could not remain long unresolved. The socialist Kyaw Nyein displaced Than Tun as the general-secretary of the AFPFL, and the Communists were expelled from the league in October, a move ratified by the league's General Congress the following month. In the speeches explaining the expulsion, Aung San denounced the Communists for seeking to wreck the unity of the country, for putting their own party above the cause of Burma's independence, and for following the dictates of the Indian Communist Party blindly without considering whether their methods were suited to the Burmese situation. Thein Pe, who resigned from the Executive Council, retaliated by declaring that Aung San and his colleagues had become more reformist than revolutionary. "They have surrendered to British duplicity," he said. "They are deplorably weak-kneed in their dealings with the Governor. And they are intolerant of criticism."[15]

Although the Communists and the AFPFL parted company, Aung San, who greatly desired leftist unity, retained his attachment for Marxist socialism and for

individuals within the Communist Party. He had tried to reconcile the "Red" and "White" factions, and after the expulsion of the Thein-Than group from the AFPFL, it seemed he contemplated an amalgamation of the PVO and the socialists to form a Marxist League. The new Executive Council also lifted the ban on Soe's Communists, but they were inflexibly committed to the path of armed revolution and once again had to be declared illegal in Janaury 1947. Many of the Communists, both "Red" and "White" and in particular ex-PBF servicemen, retained a deep regard for Aung San, who for his part did not seem to have ruled out entirely the possibility of a reconciliation right up to the end of his life. But he would allow no ideology to come before the cause of Burmese freedom and unity.

In December 1946 the AFPFL accepted the invitation of the British government to come for talks to discuss the steps that would be necessary to constitute Burma a sovereign independent nation The delegation which left for London early in the New Year was headed by Aung San and included several Councillors, politicians, and civil servants. At a press conference during the stopover at Delhi, Aung San stated that they wanted "complete independence"; there was no question of dominion status. He also said in reply to a query of the press that they had "no inhibitions of any kind" about "contemplating a violent or non-violent struggle, or both" if the demands of the Burmese were not satisfactorily met. He concluded that while he hoped for the best, he was prepared for the worse.[16] This was no more

than what he had said in greater detail in his new year's speech just before he left Burma. He had spoken frankly of his inclination to believe that the British wished to make a peaceful settlement, which he himself would greatly prefer to armed revolution, but asked the people to be ready for a struggle "outside of the law" if the necessary agreements were not reached. Aung San and the AFPFL had in fact made arrangments for arms to be gathered and for the PVO to be kept in a state of readiness in case the talks with the British government should fail.

Aung San's part in the discussions which resulted in the "Aung San - Attlee Agreement" was described by Tin Tut, an independent Councillor and member of the delegation to London, as follows:

He sought the immediate transfer, actual and legal, of responsibility for the government of Burma to a Burmese Government pending the election of a constituent assembly and the framing of a new constitution. The legal transfer he did not obtain but the actual transfer he obtained in effect though the transfer would be based on convention. It was a formula which could be twisted into a failure of the Burmese Mission which he led. He was firm in his minimum demands though with the heavy responsibility of knowledge that a revolution might result from that firmness. He was statesmanlike in the acceptance of the substance of what the Burmese people desired, a clear and short road to freedom with immediate actual responsibility for the government of their own country. Having accepted that compromise he put its implications plainly before his people and led them to work the settlement, pledging himself boldly that if his lead is followed, full political independence would be attained

within a year. This was no light pledge for he staked on that conviction his political career, his honour, and his life. He thereby proved to the full his capacity for leadership.[17]

Two members of the Burmese delegation refused to sign the agreement — Saw, the former Prime Minister, and Ba Sein of the Dohbama Asi-ayone, who had shared with Tun Ok the leadership of the minority Thakin faction after the 1938 split. On getting back to Burma, Saw and Ba Sein joined Ba Maw and Paw Tun, another former Prime Minister, to form the National Opposition Front, claiming that Aung San had gone over to the imperialists for the sake of holding office.

Aung San was not unduly troubled by the accusations of his political opponents and plunged straight into negotiations with ethnic minority groups within the country. The agreement reached with the British had left the future of the frontier areas to the decision of its people. A conference to settle the issue had been scheduled to be held at Panglong in February, a matter of days after the delegation's return to Burma. The Panglong Conference, which produced an agreement acknowledging that freedom would be "more speedily achieved by the Shans, the Kachins and the Chins by their immediate co-operation with the Interim Burmese Government",[18] was the culmination of Aung San's mission to unite the diverse races of Burma, which had begun with the Thakins' wartime efforts for racial harmony. Again in the words of Tin Tut, "It was his [Aung San's] personality no less than his directness and candour that won him his victories on the field of negotia-

tions, and his greatest achievement in that field was the complete confidence he had inspired among the frontier races and other minorities."[19]

Immediately after the Panglong Conference, Aung San went on a gruelling tour of the country, campaigning for the AFPFL in the forthcoming elections in April. A unique relationship had grown up between the Burmese public and their young leader, who had just turned thirty-two. Everywhere Aung San went, vast crowds braved the dust and heat to come to look, to listen, to demonstrate their solidarity with "our Bogyoke", a term that originally indicated his military rank but became an expression of deep reverence and affection. Aung San was not a fine orator; his speeches could be monotonously technical, rambling, and very long, but the people listened with quiet respect, matching their moods to his, delighting as much in his blunt admonitions as in his rare jokes. The public meetings were always peaceful, well-disciplined affairs.

Aung San was constantly searching for ideas and tactics that would provide the answers to the problems of Burmese independence and unity, and he carried the people with him in his search. He was not afraid to change his mind if the needs of the times warranted it. He would explain his views and motives openly to the public and ask for their support. But he made no facile promises of easy victories or utopian vistas, pledging only that he would act honourably by his country, give of his best to the cause of Burmese unity and freedom, and lead the people to those twin goals if they would

place the strength of their united wills behind him and the AFPFL. The people of Burma responded by returning in the elections an overwhelming majority of AFPFL candidates, only a handful of seats going to the independents and the Communists. The "Saw-Sein-Maw" group had boycotted the elections, knowing that there would be certain defeat for them. Allegations of undue pressure were made against the AFPFL, but the findings of the election tribunals indicated that the results had been a fair reflection of the people's choice.

The final phase of Aung San's life saw him developing daily in political maturity and statecraft, his innate ability and sense of responsibility coming into full play as he faced the challenges of nation-building. It was during this period that he won the respect of many erstwhile British adversaries, one of whom wrote:

> Aung San was to develop statesmanlike qualities which showed that his character could grow with events. For the last ten months of his life he was virtually prime minister, realizing, for the first time, the size of his country, the plurality of its races and the complexity of its problems; the volume of work told on his health and at times he was out of his depth but he was man enough to acknowledge it, winning the respect of the British administrators with whom he was now in daily contact. His assassination deprived his country of the one man who might have able to enforce discipline on his followers in the lawless years that lay ahead.[20]

At the beginning of June, Aung San convened a series of conferences at the Sorrenta Villa in Rangoon,

to plan a programme of rehabilitation for the country. In his inaugural address he underlined the most pressing issues, emphasized the need for practical and flexible approaches, cautioned against over-ambitious projects and mentioned the importance of deciding priorities. He also warned of the futility of wasting time and energy attacking and blaming imperialism for all the ills of the nation now that power was back in the hands of her people, for he was fully aware that the weapons used to fight imperialism were not always the right tools for preserving and developing an independent nation. Aung San looked ahead to the time when Burma would take her rightful place in the family of nations and saw that true nationalism would have to be "an essential complement to true internationalism".

Never hesitant to speak the truth, painful or otherwise, Aung San in his last public speech on 13th July 1947 exhorted the Burmese people to mend their ways, urging them to cultivate discipline, perseverance, and self-sacrifice and to remember that it would take years of toil before the benefits of independence could be savoured to the full. With his honesty and capacity for self-assessment, Aung San was also conscious of the need to remedy his own shortcomings, as he admitted to friends. What had been tolerated in a young student revolutionary would not be seemly in the leading stateman of the nation; there were rough edges to be smoothed, that inconvenient temper to be curbed, and social niceties to be observed, however tedious.

Plans for the official transfer of power proceeded

apace. The AFPFL laid down their independence policy at a convention in May, and a committee was formed to draft the constitution of the independent sovereign republic which was to be known as the Union of Burma. As the goal for which he had laboured so arduously came within reach, Aung San appeared relaxed and mellowed, visibly different from the tight-jawed young military commander who had led his army through the Japanese resistance. There was about him an air of quiet reassurance, almost of serenity. But there was also a deep weariness. He spoke of his desire to leave politics once independence had been achieved, to devote himself to his family and to writing. But it was not to be. On 19th July, during a meeting of the Executive Council, Aung San, together with six other Councillors, including his elder brother, Ba Win, a senior member of the civil service, and a young aide, were assassinated by uniformed men who burst into the unguarded conference chamber with machine-guns.

The assassins escaped, but they were quickly traced to the home of Saw. The former prime minister was man of large ambitions who had not been able to accept the rise to national leadership of Aung San, whom he was wont to describe as a "mere boy". Shortly before Saw had joined the Burmese delegation to London, he had been shot at and wounded in the eye by men dressed in khaki. There were those who surmised that Saw had believed Aung San's PVO members to have been responsible for the shooting and therefore sought revenge. But the trial would reveal that the instructions had been for the

whole Executive Council to be destroyed, and it seemed that Saw had sought the death of Aung San and his colleagues in the strange belief that once they had been removed, he would become the head of the Burmese government. He was found guilty of abetment and sentenced to death.

Although Aung San had died, the independence to which he had dedicated his life came to his country. Nu, the most senior member of the AFPFL left alive, completed the final negotiations, and on 4th January 1948 the independent Union of Burma was born.

Conclusion

IT WOULD perhaps be appropriate to quote here the words of Frank N. Trager, an American scholar of modern Burmese history:

> It is a distortion of history to account for events solely in terms of the actions of a great man, and to the extent that these pages imply that, they evidence such distortion. But, given the conditions in Burma, it seemed proper to examine the record for the twelve years beginning when the Thakins first achieved political office, to the dawn of independence in January, 1948, in terms of the ambient leadership of Aung San.[21]

The converse of this is also true, for Aung San's life can be studied only against the backdrop of the Burmese independence movement, even if such an approach neglects much of his personal side. But since the time he entered student politics in his early twenties, his existence had been inextricably bound up with the struggle for independence, and he was not one to adopt a public image different from his private character. The total picture is one of a young man of great integrity and strong character who led his country to independence with single-mindedness and a high sense of purpose. Accusations of ruthless ambition, unreasonableness, and duplicity have been made by some political opponents and by those who saw his fight against the foreign

rulers of his country as "treachery". Such charges have to be evaluated against a consideration of the record of his actions and achievements. As long as he believed that another was better able to provide the leadership, he had accepted subordinate positions readily, assuming the central role only when it became clear that he was the one man who could unite the country and lead it to freedom. In the words of Kyaw Nyein, who had been a close political associate since his student days, "leadership was not given to Aung San, he earned it by his many qualities".[22] Aung San was subject to moods and emotional outbursts, but his personal feelings and inclinations were never allowed to interfere with the collective decisions taken in the interests of independence politics. At each stage of the struggle, he worked in consultation with close political associates, accepting justified criticism and delegating responsibility when it seemed best. He would not tolerate self-seekers, irresponsible actions, or dereliction of duty which threatened the independence cause. He believed in the principles of justice and democracy, and there were times he deferred to colleagues when he might better have trusted his own judgement. As head of the Executive Council, he did not impose his views on others; decisions were reached after free and full discussions. He was not infallible, as he freely acknowledged, but he had the kind of mind that did not cease expanding, a capacity for continuous development.

Aung San's appeal was not so much to extremists as to the great majority of ordinary citizens who wished to

pursue their own lives in peace and prosperity under a leader they could trust and respect. In him they saw that leader, a man who put the interests of the country before his own needs, who remained poor and unassuming at the height of his power, who accepted the responsibilities of leadership without hankering after the privileges, and who, for all his political acumen and powers of statecraft, retained at the core of his being a deep simplicity. For the people of Burma, Aung San was the man who had come in their hour of need to restore their national pride and honour. As his life is a source of inspiration for them, his memory remains the guardian of their political conscience.

On the following three pages is reproduced a letter dating from March 1945, from Aung San, who was then directing the resistance against the Japanese, to Dr. Ba Maw who was held in Rangoon.

Shwedaung

My dear Adipadigyi,

I am sorry that I was unable to meet you before I came out here as I had promised you. Conditions were such that I had to do things in a hurry. Sometimes, I am afraid you might misunderstand me. I shall be coming back to Rangoon &, if conditions do not worsen so unexpectedly, I hope to meet you again. Meantime I wish to send you some report.

As I said in my speech, I would do my best to save the situation. But as you would also understand, these are

—56—

dark days for us. The Japanese troops are withdrawing to all intents & purposes. And I shall not be surprised if, before moonsoon, the war in Burma is over. Anyway, I think I don't blame the Japanese too, for from the strategical point of view, if you might understand, this is the only wise & sound course for them to do. Nevertheless there is still ~~about~~ hope ~~for~~ for us ~~possibilities~~, I suppose. ~~But~~ ~~However~~ ~~now a days~~ Of course, we shall have to be prepared to struggle alone for sometime. But I have every confidence that our cause will win ultimately. War or no war, peace or no peace,

the struggle for our national independence
must go on till it ends in victory.
~~[crossed out] the japanese authorities~~
~~that~~ And I will do my best. You
might misunderstand me now
perhaps. But believe me, after
sometime, you will see whether
I mean what I say. At present
~~I~~ have to fix up ~~many things~~,
because there are so many angles
to be ~~xxxxxx~~ straightened. Meantime
I wish you to be prepared for
the worst & do whatever possible
in your line.

~~Please pass orders~~ to Ed.
~~xxxxxx about getting diplomas~~

yours
[signature]

—58—

Notes

1. Aung San, "Burma's Challenge", in *The Political Legacy of Aung San*, ed. J. Silverstein (Ithaca, NY: Cornell University Southeast Asia Program, Data Paper no. 86, 1972), p. 55.
2. Aung San, letters to Tin Aung, circa 1935, extracts quoted in Tin Aung, "My Recollections of Bogyoke Aung San", *Guardian* (Rangoon), August 1971, p. 15.
3 Aung San, *Burma's Challenge*, pp. 45-46.
4 *Ibid.*, p. 46.
5 Izumiya Tatsuro, *The Minami Organ*, trans. Tun Aung Chain (Rangoon: Universities Press, 1981), p. 26.
6 Keiji Suzuki, "Aung San and the Burma Independence Army", in *Aung San of Burma*, ed. Maung Maung (The Hague: Martinus Nijhoff, 1962), p. 58.
7 Aung San, *Burma's Challenge*, pp. 46-47.
8. Maung Maung, "Aung San's Helpmate", in Maung Maung, ed., *Aung San of Burma*, p. 117.
9. Papers of Eric Bettersby, extract quoted in Maurice Collis, *Last and First in Burma*, 1941-1948,(London: Faber, 1956), p. 205.
10. Aung San, "Blue Print for Burma", in *Political Legacy of Aung San*, p. 14.
11. Sir William Slim, *Defeat into Victory* (London: Cassell, 1956), p. 519.
12. Let Ya, "The March to National Leadership", in Maung Maung, ed., *Aung San of Burma*, p. 52. See also Thein Pe, "A Note from My Diary", in *ibid.*, pp. 85-86.
13. Aung San, "Statement of General Aung San, Commander, P.V.O. May 8, 1946", in *Political Legacy of Aung San*, p. 30.
14. Aung San, speech delivered at the protest meeting against the White Paper, 29 September 1946, in *Bogyoke Aung San Meingun Mya* [The Speeches of Bogyoke Aung San] (Rangoon: Sarpay Beikman, 1971), p.140.
15. Aung San, speeches delivered to explain why the Communists

had to be expelled from the AFPFL, 20 and 28 October 1946, in *Bogyoke Aung San Meingun Mya*, pp. 142-59. Thein Pe, quoted in "Burmese Communists Bid for Success in General Elections", *New Times of Burma*, 30 October 1946.

16. Quoted in Maung Maung, ed., *Aung San of Burma*, pp. 104-5.

17. Tin Tut, "U Aung San of Burma: A Memoir", *Burma Review*, 25 August 1947, p. 12.

18. "The Panglong Agreement", reproduced in Maung Maung, *Burma's Constitution* (The Hague: Martinus Nijhoff, 1961), Appendix III, p. 229.

19. Tin Tut, "U Aung San of Burma", p. 12.

20. F.S.V. Donnison, "Unifier of Burma", in Maung Maung, ed., *Aung San of Burma*, p. 148.

21. Frank N. Trager, *Burma - From Kingdom to Republic* (New York: Praeger, 1966), p. 89.

22. Kyaw Nyein, "He Made a Dream Come True", in Maung Maung, ed., *Aung San of Burma*, p. 146.

Select Bibliography

Much of the foregoing account of Aung San's life is based on Burmese material, but the following represent some useful sources in English.

Ba Maw. *Breakthrough in Burma: Memoirs of a Revolution, 1939-46.* New Haven, Conn.: Yale University Press, 1968. The story of the Japanese occupation of Burma by the man who was head of state during that period.

Collis, Maurice. *Last and First in Burma, 1941-1948.* London: Faber 1956. An account of the last days of the British administration in Burma and of the negotiations for independence.

Donnison, F.V.S. *Burma.* London: Ernest Benn, 1970. Intended by the author for the general reader, this book contains several chapters on the Burmese independence movement.

Izumiya Tatsuro. *The Minami Organ.* Translated by Tun Aung Chain. Rangoon: Universities Press, 1981. The eighteen-month history of the Minami Kikan, told by a man who was one of its members.

Maung Maung, Dr. *Burma's Constitution.* The Hague: Martinus Nihoff, 1961. A detailed analysis of the September 1947 Constitution preceded by a brief political history of pre-independence Burma.

Maung Maung, Dr., ed. *Aung San of Burma.* The Hague: Martinus Nijhoff, 1962. An anthology of articles on Aung San which includes some of his own writings and speeches. Those works which Aung San wrote originally in English have been heavily edited.

Maung Maung, Dr.. *A Trial in Burma: The Assassination of Aung San.* The Hague: Martinus Nijhoff, 1962. Contains the story of the events leading up to the assassination, a detailed account of the trial, and the judgement of the Special Tribunal in full.

Maung Maung, U. *From Sangha to Laity: Nationalist Movements of Burma, 1920-1940.* Australian National University Mono-

graphs on South-East Asia, no. 4, New Delhi, 1980. By a different Maung Maung (U rather than Dr.) from the author/editor of the above three works, contains much factual information and copious footnotes.

Maung Maung Pye. *Burma in the Crucible*. Rangoon: Khittaya Publishing House, 1951. One of the first books on the Burmese nationalist movements from the end of the nineteenth century to the achievement of independence in 1948.

Nu, Thakin. *Burma under the Japanese*. London: Macmillan, 1954. Nu was Foreign Minister during the Japanese occupation and later became the first Prime Minister of independent Burma.

Nu, U. *U Nu: Saturday's Son*. New Haven, Conn.: Yale University Press, 1975. Written after Nu had discarded the *Thakin* prefix, this autobiography ends with the military takeover of Burma in 1962.

Silverstein, J. comp. with introduction. *The Political Legacy of Aung San*. Ithaca, NY: Cornell University Southeast Asia Program, Data Paper no. 86, 1972. A selection of Aung San's writings and speeches in English, including the whole text of Burma's Challenge (Rangoon, 1946), a collection compiled by Aung San himself.

Slim, Sir William. *Defeat into Victory*. 2nd ed. London: Cassell, 1956. An account of British military operations in Burma, 1942-45. Includes material on the negotiations between the Allied forces and the Burmese resistance troops.

Tin Aung. "My Recollections of Bogyke Aung San". *The Guardian* (Rangoon), August 1971, pp. 13-15. Rare personal glimpses of Aung San by one of his closest friends.

Tin Tut. "U Aung San of Burma: A Memoir". *Burma Review*, 25 August 1947, pp. 11-12. Tin Tut was a senior civil servant under the British who later left the service to join the AFPFL. Finance Minister, then Foreign Minister. Assassinated September 1948.

Tinker, Hugh. *The Union of Burma: A Study of the First Years of Independence*. 4th ed. London: Oxford University Press, 1967. Contains a chapter on the British rule in Burma and the

independence movement.

Trager, Frank N. *Burma - From Kingdom to Republic: A Historical and Political Analysis*. New York: Praeger, 1966. Largely devoted to post-independence Burma, but contains several chapters on pre-independence politics.

* * *

Tinker, Hugh, ed. *Burma - The Struggle for Independence: Documents from Official and Private Sources*, vol. 1, *From Military Occupation to Civil Government, 1 January 1944 to 31 August 1946*. London: H.M.S.O., 1983.
From General Strike to Independence, 31 August 1946 to 4 January 1948. London: H.M.S.O., 1984. These voluminous compilations unfortunately appeared too late to be made use of in the present work.

Maung Maung, U. *Burmese Nationalist Movements, 1940-48*. Edinburgh: Kiscadale, 1989. Also relevant, but published after the compilation of this work.

Index